FAITH, UNITY, DISCIPLINE

MUHAMMAD AZAM ZIA

authorHOUSE®

AuthorHouse™
1663 Liberty Drive
Bloomington, IN 47403
www.authorhouse.com
Phone: 1 (800) 839-8640

Published by AuthorHouse 11/18/2015

ISBN: 978-1-5049-6130-1 (sc)
ISBN: 978-1-5049-6129-5 (e)

Print information available on the last page.

Any people depicted in stock imagery provided by Thinkstock are models, and such images are being used for illustrative purposes only. Certain stock imagery © Thinkstock.

This book is printed on acid-free paper.

Because of the dynamic nature of the Internet, any web addresses or links contained in this book may have changed since publication and may no longer be valid. The views expressed in this work are solely those of the author and do not necessarily reflect the views of the publisher, and the publisher hereby disclaims any responsibility for them.

In the loving memory of Abbu, my father

Dedicated to my mother who taught me how to read,
My brothers and sisters, Uzma, Khurram, Nadya, Majid, Ashad
My children Arham, Reham, Raahim and Saaim
And, the love of my life Seeme.

CONTENTS

INTRODUCTION

The routine nature of our present day life eludes straightforward opportunities to think beyond the obvious, to think beyond monetary, and to feel the charm of life's many beautiful inconsistencies. The wrinkles on the faces of people, the aura of human relationships, the smile of the poor, the pain of the rich and the dilemma of convenience-based bystanders. Yes I am one of the many who dwell towards territories unknown, assessing the practical and pragmatic purpose of the unsaid. Today I stand as my own man, out of the shadows of the many I have read and tried to understand. Here I am, Azam the poet.

My poetry implores ways to recognize contemporary circumstances in an unorthodox and nostalgic manner so as to draw attention to life's raw deal. There is contempt but with a noble motive: the desire to bring change in the thinking of the reader. Its principle reason over the long range is to bring about change through peace, hope and inspiration. One might say that it seeks to give us a fresh viewpoint on the incongruities and evils we live among, the evil we ignore or the evil that we, ourselves are.

I welcome the reader to my world of poetry. Faith, Unity and Discipline is a collection of thoughts, a compilation of memories, a basket of hope, and a plea for humanity. Some pieces question the accepted norms of everyday life and some pieces try to knit together the puzzles of faith and sincerity of effort. Each poem should be read under individual light as they were written in a spirit of independent thinking. If found and read after the life of the poet, the reader is urged to try to imagine the thoughts that must have influenced the writer.

After all, imagination is the most spectacular sense we, the humans possess.

Lost the religion and now worldly,
Democracy, not a matter of sanity,
Breaking free will take effort of quality,
Faith, trust and shedding of liability,
Purpose of freedom is to create it for others,
Blood of my sons, sacrifice of your brothers,
My word is unable to dub supreme causes,
A sheer reflection of my life's losses

YOU

Was nowhere, this life, my ability
Fortunes were distant anonymity
Days were dull, nights in complexity
Hours were rushed, minutes duplicity
Emotionally I was unknown commodity
Subject to pretty, though evil extensity
Heart was an untamed impossibility
Often uncontrolled on visual serenity
Bridging the gaps of my personality
Along came you to ignite my sanity
Withdrawing my sins of individuality
Infusing that vigor of family solidarity
Teasing me with absolute femininity
Tossing my soul towards humanity
Invoking a passion dead in ambiguity
Sparking a poet through my versatility
Creating a bypass on my anger atrocity
Realizing my potential by way of humility
Increasing my humane value, tenacity
At times bearing the brunt of my calamity
Raising a person from a heap of chastity
Born again a better son, brother, paternity
Giving me much amid cautious spirituality
You are my friend, my love, my eternity

A POET OF SERENITY

I am a poet of serenity, anonymity
She is the wind, the soul of my versatility
Today's world is of mobility, virtuosity
I still seek pleasure in tranquility
Gone are the days of familiarity, neutrality
These times are of brutality
Peace has embraced calamity, poverty
I give donations to embarrass morality
The war is on for nationality, migratory
Son of the soil – stupidity
They preach me religion, continuously, effortlessly
I seek divine love, unconditionally
They are reaching stars, galaxy, and universality
We are still seeking clarity on basic practicality
I was a poet of serenity, anonymity
Now I want a stir, a war, answerability

MY WORD

You have put a question on my word
I think of what you did observe
Practicality, beauty and history
When have I asked helotry?
Nostalgia is the magic I like to create
To tease some senses is what I make
Love is such a beautiful tale
Who hasn't thought of its fate?
People around me are whom I course
Is there time still to remorse?
Fire from this heart is loud
Not keeping it within my cloud
Can't we all put a match to this fuel?
Ending the misery of yesterday's duel
You are me and I am you
Thin ice is the differ in two
Satan is within so these flames are known
Aren't we all hell prone?
The questions no doubt will be three
Heaven will be through that bridge not free
We will all account for the hearts broken
In this journey of life molten
My word is unable to dub supreme causes
A sheer reflection of my losses

I MIGHT

I might, you might
Overcome the odds of right
Give the zeroes a fight
Stretch hope beyond the limits of sight
Skip the clouds and pull that weight
Crisp the homeland with freedom so bright
Stun the blue eyes to see freedom so tight
Press for charges against uncle blight
Bowl him with that loop and flight
Switch the bulbs on terror and fright
Panic my soul to live the night
Live the book where answers light

FAITH, UNITY, DISCIPLINE

Reporting on the tumultuous demise
Again I return to similar compromise
The devil's garden, one may criticize
Half a century but no golden era realize
Ponderosa boys of the Muslim wise
Pakistanis, a shadowy presence despise
Crying foul, contributing factor parasitize
Hindus, Jews, mostly the plot to Americanize
Wealth in Baluchistan, oil in Sind's franchise
Frequent is our self-defeating dreamy incise
When was Swat safe, let's honestly equalize
When was peace in the north bureaucratize
Leadership supreme reroute to industrialize
Schools bled profusely on our way to democratize
Schools bled profusely on our way to democratize
Business as usual as we fight to revolutionize
A war bringing more terror yet we fail to up rise
Short cuts our preference, dishonesty our demise
We have seen the worst let's rise, let's improvise
Favor justice, teach our kids hard work, and moralize
Use these losses as lessons, learn Japan's focalize
Education the key to degenerate our image demonize
Sponsor a child's schooling, if you care to formalize
Second largest Muslim nation tottering in disguise
Faith, unity, discipline, the values we must reprise

Method in this madness

Strapping a bomb to self is no bravery
Quenching one's blood thirst is ugly
Magnifying thy future to heaven is holy
Amplifying anger to that level is gorsy
Awaiting seventy two sweeties though rosy
Interpreting religion to own liking, is anomaly
Glorifying murder is nevertheless butchery
Abusing laws of nature will cost some dearly
Accounting for oneself is difficult already
Grapping sins of others is insane, clearly
Killing one weighs as killing mankind totally
Agonizing are punishments in hell, brutally
Advocating hatred is selling wisdom cowardly
Nothing more than daylight values robbery
Awakening justice, peace is moral reality
Starting from home, own kids is cleverly
Saving children will be saving humanity
Dowsing so many to death gross brutality
Approving suicides as martyrdom is guilty
Cruelty the method in this madness only

Moment for adamants

One seventy million inhabitants
Eyes of all but only in anticipants
Captured hearts by foreign giants
Rules, laws, judiciary with infants
Leadership of inglorious tyrants
Cream of people towards migrants
Cheating common, fraud relaxants
Naïve thoughts our suppressants
Romancing with faith our errants
Mix of wrongs on right the excitants
Let's become meaningful habitants
Behold the fort Iqbal's lieutenants
Inhale the fear and exhale combatants
Spank illiteracy, inequality pollutants
Enemy within, why search for militants
Counterattack soul-decaying colorants
History can be written by keen debutants
Pakistan was formed by daring guardants
1940, Lahore stood the resolution aspirants
Jinnah, along with several determinants
Nuclear our strength, Islam descendants
March 23rd, still the moment for adamants

WHY AFGHANISTAN?

Military actions, strong get the weak
Domestic justice, weak gets the tweak
Case in point the justice of uncle Sam
Strange interest in spooky Afghanistan
What is right and what is wrong?
Indispensable to the Pentagon
Turned away from the mission
Mess, a huge, crap of Afghanistan
Hospitals loaded, schools under ban
Washington's cry, there's Taliban
Recession got the better of every man
Weaponry not a problem though in Afghanistan
Scores dead in day night groans
Brilliance to kill evil with drones
Kabul rattled, Kandahar without trace
Millions homeless, what a disgrace
Russia and China, and encircling Iran
Helpful neighbors and then Pakistan
Icing on the cake is this war to stabilize
All the president's men here to advise
Villains created to keep the attraction
The world watches this commotion
How wicked can be illiterate Afghans?
Yet monsters they are to humans
Stop this atrocity while you still can
Troops, missiles and every barbarian
Victory will come only through Afghans
When books are traded with weapons

Both ends of this divide

Flapping wings with arrogant stride
There goes a bird from west to side
What is subversive about this glide?
Is the animal's free will to ride?
Ironic again the subject I decide
Humans in cages as animals chide
Superior is mankind and yet we collide
Knowledge and wisdom, and a guide
How did we use our higher tide?
Fences outer and borders inside
Remarkable is our fear to confide
Jealousy and hatred what we hide
Expectations of lord we must abide
Our boat however on constant slide
Religion, color, race or nationwide
Hearts the place for Satan to reside
Lessons all around, animals provide
Rinse your hearts, minds and pride
Patience key for humanity to coincide
Tolerance but, both ends of this divide

The Arab awakening

Enough is enough is the song
Stop those thugs in seats since ages long
One by one they all must fall
This is the Arab awakening our call
Out on the streets are men, women and all
Liberation of Tunisia, Egypt and Libyan wall
Severe cracks in Syria and Yemen sights
Freedom of will, decent life and rights
Revolutionaries will not settle for anything rife
Oppression is not the only mode of life
Let there be freedom for Muslim or other
We are together, brother to brother
Honesty however must prevail
Let no intruder through our veil
Up, above the world so high
Might is in Arabs still, not old sigh
Open schools and get to work
There is more that needs rework
Let's build nations not new governments
Seek real beauty beyond all ornaments
Put all guns down and avail peace
Think before we feed the beast
Remember Afghanistan in recent memory
Russians left but not his weaponry
What was bad became so worse
People prayed for slavery, freewill curse
We need love and care after all the hurting
Blessing, not a curse this Arab awakening

FREEDOM FROM SELF

Impetuous dreams of change glide towards fade
Through the hammer of this unforgiving decade
I kneel down near the end line of hope barricade
As others, similar to me pass in success charade
Storms so many withered any chance accolade
Corruption much, every arm a sharpened blade
Cuts, bruises, shock, pain, impossible to evade
Wrong so common, right if found is cheap grade
Rich dwell in foreign visa, poor with gun, grenade
Every line crooked, every promise a high crusade
Leaders so many but leadership stale, joke façade
Tsunamis self-proclaimed, victories but in dissuade
Humanity victim, greed the tormentor we made
Are we different to phone cables in our arcade?
Good in blame, better in finger pointing trade
Nothing in order, hope the bestselling ballade
Immigration the route for the literate brigade
Stuck with the war is the option less comrade
Each morning worse than the previous shade
Victory march, terror is completing the invade
Let's break shackles and bring down the escapade
History once did uphold us as a bright green jade
Honesty a must, tolerance, equality must abrade
Freedom from self, 1947 promise is then remade

THE LONG SHOT

Little would have that stern critic known
Winds like such would he have blown
Imran will rise to heights beyond that fence
Humble beginning he broke through their defense
His success is his open record over others
Past failures, corruption dwellers and the brothers
Quest towards winning cricket was his youth
Now restoring pride of a nation north to south
Cancer hospital must be his most notable flight
He is the lion with the arrow and the might
If a past so dull could raise him to such height
I hope my children too dwell a similar fight
The proudest a Pakistani mom could be of a son
Those stark efforts, that stance, no comparison
He is the hope most now acknowledge
No magician but surely with that knowledge
Of winning, of correcting of hearing the agonies
Pleas of the poor, the burdened the hidden stories
Make no mistake; the chance of change is now
How can past failures still seek another show?
Hit so much the dear nation is beyond bleeding
Gasps, desperate howls, Pakistan is not breathing
Years of turmoil have created that pollution
We all have participated in this corruption
Maybe not all honest in his political drive
The difference in philosophy, vision will suffice
Khan is here, injured, ruffled and extremely hot
Azam has, will you too play the long shot?

WHEN EAGLES FALL

It surprises me, surprises me everyday
How life and seasons and people change
Promises and roses do not bloom
Murky waters left by dirty shoes
Friends and foes, foes and friends
I sit and wonder at nights alone
What people see and what people feel
Winning hearts needs a fool
Mythical thoughts
Destroy what took ages to groom
I think at times, times of crown
Justice is what I recall
Hopes of mine
Showers of rain
Down they fall, down they poured
Lost islands and lost worlds
Find a dawn
People hurt, find a soul
But when eagles fall
They fall forever....

PEACEFUL COWARD

Sitting on toiling reserves, I save myself
Biting those pillows, breaking pencils at my desk
Pitying the images of brutality amass
Piling up guilt without a task
Taming the war we have beneath
Coaxing the beast which ensures equal peace
What is it if not ignominy?
Expressing truce when war is necessity
Charity and a peace march
Burning effigies as an anger larch
Today it cries, the Islam we claim
Children slaughtered with shells and winch
Fun is aplenty to see us all
Calling God when we have lost
Where are the horses we had to prepare?
In times like these of tyranny and scare
Weak thoughts, twisted tongue, shivering tender
Where is yesterday's terrorist, Islamist, tormentor

BIRTH TO GRAVE

Is this the way life was to be?
Pulling our weights against the tree
Mother, sister no one spared
Money, money on they stare
How long will this class lie?
Upper, middle to lower still
Father holds that pocket tight
Son's fee, doctors' blight
Communism was born on such note
Screaming modernity – silly joke
From the place I belong
There's only one gong
Flash in my pan so high
Tomorrow's fear won't dignify
Has your job ended too?
Join this tram back to the zoo
The fault is ours whatever be
Visas, bills or the wee
Piece of bread for every site
Ah, if only did we reconcile
The system that Almighty gave
Equal rights birth to grave

VALLEY OF DEATH

Blooming flowers of yesteryear
Scattered beauty far and near
Twisted rides and food delight
Nostalgia for every young sight
God's wrath or neighbor's smear
Swat became the land of fear
Faith, culture both collide
Illiteracy added the spice
Islam's name and laws again
Misinterpreted for evil gain
Innocence subjective, offence not
Punishment rep warnings just blot
Loss of youth the bottom line
Law enforcement at high trine
The burning valley is a sign
Pakistan's north in undermine

GODSEND

I was shown the mirror this weekend
Little could I do to pretend?
Mourning the things at life's blend
Weeping on the errors of dispend
Challenges I crossed to bend
Ball in my court to attend
Joys so many to depend
Mysteries of nature still uptrend
If religion per me was in descend
My role to improve the dividend
O' Azam let's move to another end
Your soul is difficult to comprehend
Correctness of path needs overspend
Just five prayers will not amend
Flogging girl on suspicion of boyfriend
Act definitely not godsend

GREY HAIR AND A LIE

I give a damn and care less
For the wonders of this mess
Crooked streets and dark lanes
Beggars wander and droppers roam
A tale untold, a name uncalled
People wait, in queues on hold
Mothers cry their sons' goodbye
Youth runs like toilet roll
Buses rush and people escape
Death hangers and survival encaged
Mosques loud tear the skies
Minds totter, TVs, music paradise
Beauty is yes, for praise
But efforts have no trace
I give a damn and care less
For the wonders of this mess
But I lead, I won't die
Grey hair and a lie

HALF DONE

I would expect my legend to explain
Lessons of heart stomach and refrain
Achievements in aspects of life main
Agony of earnings through blood, stain
Moping burdens of middleclass terrain
Picking tricks from that annoying villain
Uncertain, sinning the religion I retain
Shadows, doubt mostly under my curtain
Anger, outrage balanced with care again
Childhood caged in depths of inner chain
Career, money all my pockets could contain
Contentment however I could never sustain
Celebrations of years lost in battles plain
Flaming my own cave still trying to regain
A light, heart to cleanse this soul in disdain
Ending my journey and a lot yet to attain
Uncertain my time left, and I must complain
Rituals eating my time, freezing my brain
Past is lost in miseries of worldly pain
If I sleep now then I will miss that train
Sides are two, the good or bad domain
Prophet's teachings we must maintain
Sixty odd the average you and I obtain
Diet or riot the end of life is certain
Half done is Azam, soul about to drain
Why not reflect on moments that remain?

Where is our tear?

Children neglected, parents unheard
Money is driving, pushing us in herds
MBAs so many yet wisdom so less
Offices perfect but homes in a mess
Coaching to improve relations at work
Family members but an alternate talk
Mother's day is cherished to soften
Mothers' poor seek love more often
Diseases are healthy, meds have failed
No sign of remorse, hope still derailed
You might be wise, but I am smarter
End but similar, smart through wiser
Bloodshed, sufferings so much to fear
I wonder where, where is our tear?
Can't we create peace on earth?
All live in harmony, birth to death
If sixty tops is our age margin
Why at forty we don't begin?
Plant trees in soil, honesty in soul
Water our fires with peace in bold
Hurricanes, earthquakes carry the sign
It is cancer, this change is not benign

VOICE OF MY VEINS

Assembling dates back to distains
A nimble homage to dark remains
All the guilt of happiness refrains
Today a sound different attains
The mellow voice of my veins
Youth bygone, survival on aspirins
Immense my emotion, timid my brains
Thought, didn't realize time abstains
Yesterday they were here my fountains
The shallow voice of my veins
Cyclic this life, hour on hour bargains
Rapid pace but surely this life maintains
Sensations around, of my story's villains
Some were lovable, I treated as toxins
The hallow voice of my veins
Hospital beds, everyone's end begins
Sizzle your eyes, brighten the margins
Selfish life is an existence in chains
Free our spirits God, rise our chins
The wallow voice of my veins
Tomorrow gone hold today's cabins
Time is less and some more complains
Think but beyond seventy virgins
Seek from that book which contains
The callow voice of my veins

Starve this hunger

Disturbing, rattling yet clamoring
Disgusting this sight of hunger
Real world snoozing, partying
Playing its game this hunger
Extra cheese and calorie biting
Running havoc, blight of hunger
Mothers dead, babies still suckling
This monstrous height of hunger
Mansions in millions, glittering
Chanting the death bells this hunger
Watching the show relaxing
Mutilating this thought of hunger
Dancing our children, enjoying
Beastly this might of hunger
Bleeding dollars fun, accessorizing
Deafening their night of hunger
Skipping the thought, ignoring
Not our problem this hunger
Hiding in excuses Azam, praying
Kneeling in the face of this hunger
Rising, supporting open protesting
You and I can starve this hunger

Burdened by the obvious

Dragging in mire, anger and gust
We dwell in matters of devious
Delay in traffic, elevator and rush
Annoyed at the sound oblivious
He got the promotion, nerveless
Basking in the agony of envious
Bad coffee, cold water, food disgust
Aching in the brightness pervious
Calorie counts, guilt in the diet
Grumbling tummies cry delicious
Back at home, fused bulbs square
Mumbling on rising bills, furious
Child's sickness, wife's chasteness
Griming at choices made previous
Mother's call, brother's fall, sisters
Digging mental pit holes cautious
Prayer calls albeit television roars
Undone by complexity religious
Mental dolls and shopping malls
Buying to relieve feeling anxious
Constant failures but schools brim
Creating a generation dubious
Life is straight, expectation is laid
We must defocus the tedious
More to be done and by everyone
Yet we are burdened by the obvious

DRONES

Rules of war have taken a twist
Amid education and knowledge mist
Surprising but collaboratively new
Men have turned to weapons in skew
What was once a show of the brave?
Is now nothing more than pity grave
Instead of fighting man to man
World has adopted to a weird plan
Sword to sword, head to head
Rules of new have many dead
The strongest are the ones with technology
Brutality, double policies and then democracy
Bombing the enemies with distant dart
Targeting others from miles thus an art
Strapping a bomb to thy body is still bold
Killing a sleeping enemy is cheap and cold

BROWN SAHIB

A friend in senior made me realize yesterday
Lost in translation of immigration is my essay
Little can I recall of my true tongue this day
Accolades in English not helped the dismay
The majestic influence was on Sir Syed's foray
Then it produced Brown sahibs of indo-subway
Speaking Urdu a burden for my son everyday
My daughter however blessed with headway
Complexity of upbringing as Imran's fore say
I do agree that people like me are in disarray
Not lose the true identity of mother's way
Why not use our own lingo for advocacy
Reaching masses only possible in known play
Through a medium they can understand today
Until that dawn on my poetic-colonial mainstay
I will daunt the task to strive my screenplay
The British raj gave us tea and railway
First Jinnah and then asylum on overstay
High with the queen's last blessings anyway
I must become the change I want to say

I SHOT HAKIM

Boisterously ignorant unfurled a shot
Not realized the loss it would cause
Took that case with notes too many
Mother needed meds, not so really
Never thought who Hakim actually was
Looked the most an old, on silly cause
Politician then with his motives unwise
Just pull that trigger said my accomplice
Close range it was when I did the skew
Unmeshed without fear I stuck the cue
His chest I chose to complete the deed
Not much he did lying on the street
Hakim was a man of many tricks
Medicine, education and politics
I shot the one who was not ordinary
Hakim Saeed, the Hamdard legendary
Wasn't his 'Naunehal', I read as a child
My soul got ripped, my conscience wild
We are a nation who kills our best
Humiliate then we of the rest
Let's shoot the evil that erupts conspiracy
Come Pakistan, let's bomb our own hypocrisy

YEARS AGO

Two decades and still a delight
Memories of that wonderful sight
Pakistan's cheer, Pakistan's night
Tigers for the world, heroes bright
Braved like those, overcame plight
Art and science sprinkled with fight
Not known were these men alright
To surprise though, was their might
Will to achieve, succeed oozed like light
Led by charisma and passion bight
Many had broken before in hindsight
Never was victory sweeter than right
Broke through norms of English fright
Imran's team did that amongst the eight
If we applied pressure that tight
We could lead the world with height
Decline but became our mission outright
Glided without an engine our flight
What was a breakthrough yester night?
Lost that bite, we vanished in moonlight
Years ago, conquered demons bedight
Today on our knees, silence our twilight

Children of the dump

Tears in my smiles
Yet curtains on my eyes
What are kids if not a joy?
Milk and biscuits, fruit and a toy
Wild smiles covered with hope
Mine are treasure theirs just load
Standing in trash with feet so hurt
They are babies, look through the dirt
Flies, what my kids find creep
Their kids play with many on feet
No calorie counts as food is none
All day's effort, just a dollar alone
Wounds so many to rejoice
My kids with meds of their choice
Children of no God
Perhaps you will nod
Scattered, barren yet Gloria
Welcome to Cambodia

BIRDS OF WINTER

As bright skies surrender
To the might of the distancing sun
A sweet panic runs through their feathers
No matter how hard they try
The winds of change just can't pull them down
An engaging struggle for endurance
Winter winds are quite a sting
There in safe locale sit a bird
Watching this momentary game
Eyes wriggle with several fears
That who had lingered back abode
Wonders why some took the lunge
When there was enough food at home
I could have flown I could have swayed
Had these wings had the verve
To Struggle for that spare crumb
For facts alone for the ones who need
Some birds need not risk to enthuse
Life for some, enough with basic warmth

THROUGH THE DEAD

The power of this tale is such
Barriers of faith have gone combust
Holy shrines are a sight to watch
Music, dance and money march
Graves of the pure slouch in barren
Others whoever lightened in heaven
Chanting verses a lovely deal
Not on grounds where nothing heals
Children so many with no clothe
Sheets aplenty on unwanted rote
Putting faith in the dead in unreal
Sorrow in my emotions I can't conceal
Flowers will bloom wherever you try
Gardens of Aden or harden sigh
This chance is special let's not waste
Do deeds proper in known chaste
Why channel prayers through any
Aren't methods explained already?
Take the path of truth though long
Not to puzzle right with wrong

AMONGST US

When you feel that chill unwise
Remember there are others in disguise
Living and perhaps breathing, fire if not air
Teasing and liking the ones in splendor
The touch is known to some not all
Feeling however is new to none
Darkness beholds mysteries of nature
Animals often recognize the sense better
There might be more in this life
More from what meets the gaze
Being afraid is not a joke
Some feel more than others vole
Imagine beings with looks of differ
Travelling quicker than the wicker
Some have heard the screams of despair
Often passing the yarn to whisper
Surely there but seldom in motion
The literary often shrug the notion
Quran has the tale specified
Allah has referred to all in plight
I too have felt strangeness amongst us
Maybe it's me, myself who is exorcist

MASTER OF DISGUISE

Lying the key to success aplenty
Usage but, at times of tough deity
Hidden, concealed, impeached in size
For years now I have been in disguise
Morality or religion the tests have passed
Middling numbers is what I sought
Trickery was such at the peak lime
I challenged the gurus in their time
Professional, master, names many
Think what may, I owned the canny
Once I touched the absolute might
Torched the spirit of brother and right
My hand of gold touched my own
I flamed the dearest into stone
Lying the key to success aplenty
Lost to truth in simple amity
Years old but the tricks hit back
Swirling the guilt of my pack
I lost the trust of loved ones and prized
Today loser, once master of disguise

Dramatization

In these resounding times of globalization
Muslims are still distant from actualization
Across borders of geopolitical mobilization
We are still encouraging victimization
Turkey is petitioning for euroization
Africa's destiny in hands of colonization
Saudi cherish bigger oil utilization
Iran's agenda still unknown visualization
Egypt into Mubarak's idolization
Pakistan's battle with talibanization
India toys Muslim voters solemnization
Indonesia's priority more industrialization
Stateless Muslims beg naturalization
Canada, Australia or other westernization
Arab league's plea for standardization
Kneeling down in front of brutalization
What did happen to Muslim civilization?
Start realization, halt dramatization

HISTORY

Today we are subject to vivid butchery
Through sites of news commentary
Not much difference in tale continually
Today's bomber, yesterday's missionary
Word of lord not understood clearly
Discussion on wives, interest, laws poorly
I call for a Muslim pope unconditionally
One version of the truth, even if monopoly
Your prayer style or mine ardently
Purpose should be defined unanimously
Use the method of elimination justly
Let's identify the wrongs precisely
No room for multi-interpretation of laws, holy
Suppress poverty, misery and monarchy
Millions dead through acts of artistry
Suicide bombing, hunger or slavery
Define what is and not a 'Jihad' exactly
Discipline, organize and explain explicitly
We are lost in oil, rule and democracy-hypocrisy
End of times distant, yet Muslims already are history

THE UGLY BRIDE

Unknowing, yet willingly she takes the ride
Heart in toss, family burdened in debt's slide
Never to utter no, never to compete
Lessons, tricks and ways to be on feet
Father's pride and mother's plight
Always respect "him" day or night
Childhood left behind, friends in tears
The moment to define all her fears
He has children from another of dead
Boys three, ages within two-years spread
Her face is bright though in a coating
Originally dark, short and bloating
She lacks the eyes or that complexion
Beauty alas only her dream mention
Opportunity to have a new secure life
Irrespective though if as second wife
Friends got married one by one
Bearing taunts she got left alone
Women are victims of sisters and mummy
My land has fatalities like her too many
She is the ugly one, though today's bride
He's twenty her senior but isn't that alright?

MY SONS, YOUR BROTHERS

I sometimes find life unworthy
Living days in cycles of mediocrity
Shameful tears as money burns
Falling prey to sublime sedate urns
What is noble about office work?
Tricks, submission, politics and rot
Unknown is my conscience on misery
Hiding my face I read news of many
Where is the self that dwelled stars?
Where is the motive to reach mars?
Lost my love for that philosophy
As I lay trapped in material zoology
I am a victim like you and them
Losing the way, halfway in tandem
End of this day I realize morality
Material is this life of subtlety
Lost the religion and now worldly
Democracy, not a matter of sanity
Breaking free will take effort of quality
Faith, trust and shedding of liability
Purpose of freedom is to create it for others
Blood of my sons, sacrifice of your brothers

KNOWLEDGE POVERTY

Through the valleys of yesterday's Spain
A dimming period twisted my brain
Pariahs of guilt went simmering my soul
As lost chapters of history brimmed unroll
Irony of a Muslim tale is seldom so sweet
Ever since the caliphs left their seats
Cordoba, a manifest of colossal research
Little known is Al Khwarizmi's patriarch
Though belittled through moral robberies
Fragrance of Andalusia still entices memories
Through the likes of Al-Jabar's anonymity
Gave algebra, astronomy, and geometry
Toiling reserves of our oil, gold, weaponry
Entrapped in others' books, methods, artistry
Saddening most are our dry visions, poor aims
Tied arms, twisted tongues and slave brains
Not one significant research in centuries
Reliance on others is our twist in mysteries
Lying dead in this mist of knowledge poverty
Where did we bury that Muslim scientists' legacy?

MY OWN STONE

Once a story of friends with pebbles
Striving together to fight the shackles
Courage and emotions both cast
Nothing to lose, attitude to last
My stone was my ray, ray of hope
Gave me the zeal, the will grope
Something happened on this road
Passion known to fight went bloat
My friend the stone went cold
Leaving me, rocking this boat
I asked my ally to reason why
It lost the charm, the will to fly
I cannot overcome that bullet anymore
Beatings across the globe syndrome
Such has become this craze
Fear has whispered lazy maze
Courage it said has been tied down
Prancing greed has played the clown
To fight it said, I need purposefulness
Faith, focus and unrivaled eagerness
Sold our souls for worldly gains
Which war, which cause, silly claims
Expecting heavenly bode against hostiles
Counting notes while neighborhood fries
Sold our conscience, the neighboring lands
Deafening peace against Zionist torments
Collective the effort endows effect
Scattered are we, in thought, aspect
Wealth galore but burdened with oil
Soul buried beneath the same, we boil
My friend then vanished, my war gone
Palestine died, hit by my own stone

EDGING CLOSER

Terrifying, disorienting, injuring humanity
Comes the tale of our tormentor's ambiguity
I will try to patch pieces through eloquence
For you, my reader in this poetic attempt
Hunch and instinct are workings of the mind
My generation but attempts more of self-divine
From the evolving business of cosmetic surgery
We feel to score goals against God's own artistry
Looks and looks gag the generations eagerly
Complementing the tipping point of atrocity
Lifted chins, crafted nose, perfect highs
Bigger eyes, wider smiles yet more cry
Tuck that tummy, blight that hair
No tomorrow, no moment to spare
In defense of diets, one more and so many
Hidden forces are subjecting false canny
Mimicry of others has sparked inner helotry
Most get under the knife as basic accessory
Knowledge free flowing to levels of drowns
Hordes of people ignoring heavenly sounds
Signs are on, the end of time edging closer
Until when will we pursue material conger
Imagine the end, ignore this beauty mist
Lust it is with a pretty face, but evil jest
Sixty years or little more is what we all get
Cherish health, seek almighty, dart the rest

WEIGH EVERY BULLET
WITH BLOOD

Feretory, ambitious, however just
My feeling – eventually truth, all nod
Millions and millions die as if must
My agony – misery for those already in fud
Justice to fathers, mothers and thrust
My notion – be prepared for the flood
Ignorance to justice, biasness disgust
My sentiment – open the doors for mud
Long has politicking gone absolute bust
My flag – burn the white, raise the crud
Simple people simple peace without dust
My theory – fight the war, ignite the scud
Children are children, mine yours unjust
My mission – treatment same be any pud
Some celebrating, others paining in combust
My issue – equality in life and freedom spud
How can Azam sleep when millions in mistrust
My hopes – throw weapons, embrace your bud
Life is short, live die or continue piercing lust
My fear – lord's anger, rapid end of time thud
Aren't we together heading for uni-holocaust
My verdict – weigh every bullet with blood

LEAVE A TRAIL

Churn the relaxant effect my son
Rise to the crisp of bones young one
Power your influence on the world
Burn the fears that numb you cold
Grip the moon with your desire
Reason your books, light the wire
Inspire with confidence blunt lethargy
Run boy run, leave walking to elderly
Withdraw from all who preach hate
Read between lines, try to correlate
Wealth irrelevant if it were for free
Plough hard, achingly plant the tree
You belong to those who were known
Resilient no matter where thrown
Gulp fuel if it turns your belly on fire
Shun meals if they dampen your ire
Muhammad's way was utter faithfulness
Gentle towards weak, hard on lawlessness
Juggle responsibility with ambition
Wear hats, husband, brother, son
Self-administer, embrace clock right
Respect day as day, night as night
Raise your value hike your conscience
You are special jot this difference
Confront easiness, value experience
Patience is a virtue, asset defiance
Great are those who hold the sail
Seek paths of new, leave a trail

THE ROT STARTS AT THE TOP

These strange, ugly moments slop
Blood thirst in our hearts must stop
Bitterness amongst us needs a mop
We must admit inner hatred is flop
Circus, jugglery of dishonesty dollop
Peace, harmony we ought to hop
Notoriety, disgrace in each, every cop
What is left, nothing more in our shop
Craving for violence needs a chop
Buck education, let books gallop
Fathers must change, mothers prop
Dirty is leaf, yet fault of the drop?
Do parents educate on mercy op?
Most leave it on teachers to slop
Controls needed on TVs and laptop
Invest in family, future will develop
Get these children to sweep, wop
Cleaning neighborhoods nonstop
If we own, train our own crop
Which place on this land will plop?
Blaming young for this day and pop
Lesson but, the rot starts at the top

I AM MY OWN ENEMY

In this story I tear the curtain
Self-trial is my aim, again
West hates me I sustain
Their education but I obtain
Life at home quirky, pain
Rules none, law in disdain
Lying common, fraud plain
Why won't lord punish with rain?
Cheating with fasting I maintain
Twenty seventh night, certain
Torching my holy book, that villain
Murders, robbery but I must retain
Prophet's cartoon my complain
Prophet's way I however refrain
Why didn't my scientists explain?
If God's book was their domain
Greater good on Azam's brain
Basic virtue I ignore to gain
Rival deep within but I strain
Looking across gates in vain
Rich richer, poor down the drain
Fault though, other nations ordain
Journey in gloom in this era main
My ship is with, but corrupt captain
Until when will I act to entertain?
End has arrived, little did I attain
Selling motherland at right bargain
I am my own enemy in this chain

SLAP YOUR SOUL

Every Tom and Susan's relative argument
Here is a country marred by banishment
Streets dark, darker my home environment
Never I felt this scared, this confinement
Howling of agony in every cruel enchantment
When will you and I do a real self-assessment?
Unsecure, mistrust, lies in every arrangement
Against odds our downward pursuit atonement
Lurching in twilight, every political excitement
Ratcheted up a notch every passing moment
Personal decision, not a government constituent
You and I will have to defeat inner evil quotient
Blaming the man in the mirror top assignment
We once promised to be a hope omniscient
Third world now ahead of us in achievement
Some should rise veering 1947 amendment
Tear these books which confuse our alignment
Comply with Lord's book, apply reinforcement
Drown complacency, indiscipline, ill treatment
Then concern ourselves on nuclear disarmament
Wisdom is a virtue, knowledge is in development
Slap our soul, jolt the bastard of disappointment

PURITY OF EVERYTHING

As if lies were nature's calling
Our lives are dark, sad, looming
Much is common in our absorbing
Moral experiences are struggling
Day in day, part of our bearing
Village or city, poor or bathing
Few amongst us truly abstaining
Then we question our suffering
How did our ethics go so begging
Most lie but rest are accommodating
No sign of any end or aborting
Serious, silly or just for laughing
Grinded in our deeper layering
Lying is widespread, accelerating
When the companions came asking
Prophet clearly went attributing
Believer can be cowardly, fearing
Believer can be miserly, non-spending
Believer can never be but lying
Let's teach kids young, start alerting
Truth is the purity of everything

....BE A RIVER

Existence of self ought to be a river
Small at first, picking steam to deliver
Contained, within own wherever
Passionately rushing past each barrier
Paving way for living, human and other
Preaching hope, freedom brighter
Flowing in the direction set by nature
Deep at center yet low on corner
A medium for verve, simple and poor
Obeying laws set by the lord, creator
Uniform, awake, amid specific frontier
Gradually receding towards grandeur
Seamless but, father, son or brother
Drops, jugs, buckets or just water
Same as similar, crying to laughter
Making way for life's next chapter
Merging in sea finally without shiver
Completing the job, tough no matter
Painlessly losing self to an end bigger
A shallow beginning but end, deeper

Faces that cannot be argued away

Abandoned baby in garbage bin
Abused maid in that hollow of shin
Accepted bribe by this police captain
Accused of crime without a proof in
Admired leader with tears unknown
Adored mistress in hope of home
Affectionate daughter's wait to rejoice
Afraid mother of son's wife of choice
Agitated parent on that school fees high
Alarmed wife at that date missed by
Alert worker covering cheating boss
Alienated nation in sanctions toss
Alive spirit without time to attend
Alone in life, though partner in bed
Alluring smile awaiting that award
Amazed child on shock of reward
Ambushed culture in shock of past
Amused father on son's height gust
Angry activist on situation so calm
Anxious look at the lines of a palm
Apologetic cry on time gone by
Appreciated talent wasted dry
Aroused emotion on cheating, lie
Ashamed human as animals die
Astonished doctor on miracle heal
Awestruck Azam on life's raw deal

BOOK FOR BOOK

Each flake of morning in towns Jewish
Mothers frame children towards anguish
Planning to net further Muslim fish
Political maps drawn on bread boorish
Coffee with blood, jam of fury, bullish
Shrieks for music, agony for beat hellish
Hitting is great, killing the way brandish
Lessons to the young ones, lot to cherish
Guns in fridges, usage guides in English
Praising the devil, hatred the sole wish
Perception the killer of others accomplish
Creating demons, distances, gust brutish
Reality an animal different, more darkish
Reality a must, for me and you to nourish
Jews ahead in education, in research lavish
They're now who we were in time warmish
Top in medicine, revolutionary and stylish
Quest for success, suppresses all languish
Then it's us who are disoriented, boyish
Many in numbers but substance in diminish
Unity missing, faith still in discussion selfish
Disarray our thoughts, actions are childish
Credit the foe, raise our game dampish
Clean our homes, society will flourish
Prophet's way we never fail to abolish
Preach by practice, flame our sluggish
If Jew mothers can raise a nation hoggish
We must enable our women to establish
Book for book is this war of times dronish
Brick for book, is what we must finish

THE BITCHES OF EASTERN BOSNIA

When Serb Gods of terror waged war
Little did the monsters left ajar
Mothers, daughters, wives, all linear
Put in camps as slaves, for joy testicular
Serb military, police or just whoever
Went merry and chose from any cellar
Fed their desires, and left them to fear
Until another's turn to sin in familiar
Life was not rosy before the conflict either
The 1990's conflict though set records sear
Worst anomaly of human history popular
Atrocities around Sarajevo beyond tear
Some were as young as twelve or near
Wrath of the monsters, methods gar
A time like no time in the history lunar
Pregnancies, disease, trauma or murder
Fifty thousand rapes, three to one year
Nations watched, casualties switched gear
Once bored of routine, daily raping smear
Camp guards became agents of the bazaar
NATO peacekeepers too, soon at the bar
Cheap girls, no offence, and the dollar
Shimmered cries of pain, insult spectacular
Dignities lost so many, and life regular?
Azam must be the judge and that beggar
Place my mum, honey, daughter, sister
Feel the pain, the shame of that time vulgar
Bitches of Eastern Bosnia and their lost scar

ISTANBUL DWELLS VALENTINE

Istanbul is majestic, sad its history divine
Museums rich, winds still carry the shine
What was once the heart of our incline?
Architecture breathtaking, a colossal shrine
Freedom, hope, authority all in combine
What it must have been, that tasteful wine
Control of most of the world in sunshine
Then the rip, curl and submission decline
Fortress of Europe, an Asian mezzanine
Aviation of standards, now a cheap airline
History books still enclose the alpine
And the last Sultan eclipsing in sideline
Secularism the reason, a philosophy fine
Changing culture, switching sides? I whine
Breaking the mold of all cultural confine
Receded entirely the Ottoman masculine
Altering the script to fit in 'their' line
Transformation so epic, complete refine
Comparison however is such a swine
Weakens my case, evaluation of mine
Symmetry in Turkey, albeit slavery hardline
Modernity enticing, a block in European spine
I wonder, could this be achieved genuine?
Without ingredients of concepts Byzantine?
Dramatic this scenario after decades nine
Muslim cities crash, Istanbul dwells valentine

...AND BEAUTY IS

Fighting to spread joy uninterrupted
Spending money on poor unsighted
Donating our best not unwanted
Planting wherever we left uninhibited
Washing hands to save others unrelated
Praying for everyone, always unadjusted
Dancing animals in the wild unattended
Winning battles of ego unlighted
Owning future of children unfettered
Hiring people for reasons unbiased
Listening to nature's focus undivided
Harvesting fruits in soil unfermented
Running on fresh grass unlamented
Walking with artificial limb unassisted
Weeping for those still un-liberated
Writing scripts of peace unmerited
Calming guilt in deeds uncalculated
Clapping with both hands unaided
Dreaming of perfection undulated
Freeing birds to skies unexploited

YOUR NAME

I have always loved you in autumn,
Autumn, so close to life
The feeling of a better tomorrow
The feeling of a new you, everyday
Charming, however you are, fresh
Your lips whisper, the leaves shank
Crisp air washes face, glooms your eyes
Shivers run through the skin
Fears of desires stroll through the souls
A fire somewhere destroys nature
And nature somewhere, destroys your age

Do you remember?

The Rain on my face
It covers the trace
of all that struggle
And of course the "LOVE"
The Rain on my face
It covers the trace
And all the tears
of anxiousness and freedom
The Rain on my face
Washes away the scars
of my yesterday
And the dark corners of my heart
The Rain on my face
Will tone me for
A new try
at love
and
at you

A YOUNG FATHER'S PAIN

Of all the wonders that He gave me
One of innocence is my child
Of all the stars that wander the skies
My child is the moon of them all
As time strolls and the child rolls
The father too learns as time unfolds
A whisper here and a scream there
All to relish, all to mold
There have been times, when I could not
Control that thing which nature told
The trait called anger, which I didn't invent
He gave me, who gives us all
What I do, when it arrives
Is seldom a case of my goals
That blackout, those moments lost
What are those, if not remorse?
Roaring and soaring
Leaving stunned looks and cool
If I can't then forgive this soul
As all I want are those cherry smiles
All I care are those magic eyes
Peace and pride
A young father's glitter and more
Sometimes joy, sometimes cold
A young father's pain
A story never told....

CROSSROADS OF MY LIFE

This eventful life, deep of emotions
Fantasies love and hate commotions
A brief little time, a time called life
I was made and fate was set
Little choices I was let
Parents who what and where
Then came play with joy abeam
Fervors, celebrations, success and steam
Came and went like a storm
Then came faith with light and sop
Restrictions, thoughts, laws and hope
Came and stayed, questioning aloft
And came love, sweet and sour
What was me was now our
Commitment, sacrifice, passion and Seymour
Now came the test, the test of souls
Bewilderment, crossroads, decisions and goals
Signs, changing times and indifference
The human inside humans
Prophecies, truth, rights and wrongs
One person enlightened another surprised

STANDING THERE SEMEE

Tough, easy and insane
Mother's love, like no name
Right, wrong or discreet
Unconditional, plenty, always sweet
Sharing the thought of the many
Standing behind is also Semee
Mother's deputy, father's leader
Holding them Semee with such smear
And when the times open the test
Of mother, father and the rest
Standing there Semee, like a net
Tears, agony yet the stretch
Problem, trouble, whatever came
Catching them Semee despite the gain
Then came the moment, one of all
Question on Semee and the fall
Fault or not, poor Semee's blame
No one to listen, non to claim
Standing there Semee still with hope
Knitting the edges of this broken lope
Mother's role, mother's be
Heaven's route beneath the feet
Empty hands, dreams but alone
Standing there Semee, today unknown

THE LOST YESTERDAY

School was pain and books were load
Teachers were too difficult to mold
Where is the youth, my friends' promised?
Money, fame and freedom uncontrolled
Today I stand in murky waters
Lying, cheating are flippant matters
Where is the fun that infancy prevented?
Me, mine, myself unfermented
Life has twisted this tale unwise
What should be mine is in disguise
Issues have taken such a twist
Pain has started through my mist
I wish I lived those days much longer
Living, not passing in material conger
Gone are the people I ignored
Lurking for things now unadorned
Now is the time my dears
Wakeup before age clears
I lost my chance and can only cry
All is in this moment, give it a try

Do it to me one more time

Once it was all easy
Faith was an easy game
Never fearing the monsoons
I engaged in the rains
Praying the right times
Strides to the place were fun
Running and hurrying
All on time and none
Time flew and things changed
End of youth was mark of man
Money came in a big way
No more peace of fate
The circles around me
Tightened to the wee
Ignorance and timing
Went too thin and awning
Truth then slapped me
Waking me to the fore
Age ticking moments behind
The soul took a rewind
Today I stand stranded
Thinking what I've done
Effect of past faith Lord of mine
Do it to me one more time

DO YOU?

Collaborating with others of far
Isolating me so near, do you?
Cheering the barrens, the rain unwed
Slipping my emotions in green, do you?
Honestly sharing warmth with many
Ignoring my tearful eyes, do you?
Dancing to the tunes of trouble
Getting annoyed at my stumble, do you?
Appreciating slightest achievement of own
Sniffing at my grand triumph, do you?
Clapping at that unknown stance
Yawning at my fable, do you?
Charming those distant echoes
Sleeping on my meadows, do you?
Loving yourself, yours in such marsh
Overlooking me with harsh, do you?
Showering accolades at own success
Thinking of England at my tress, do you?

THOSE SHIVERING HANDS

Unkind, unjust no matter how sour
Pain is reality of supreme power
Leisurely or sudden it may come
Prepared are few, strong are some
Mobility, purpose nothing spared
Where laid my chair, today despaired
Irritations first then truly aplomb
Spine, head or that kidney glom
Science solved mysteries beyond hopes
Puzzled today, lies and paltry strokes
Allah cures patients, doctors pocket fee
Always the same just differing vie
What has been written ought to be
Can't pretend, ignore or disagree
Prayers though, avert issued commands
Resurrect hope, raise those shivering hands

Are these the same kids?

Sturdy, arrogant and now self-reliant
Stands here the lot of yesteryear's drool
Clamping for power and decisions of own
Edging, skipping oldies over and over again
Youth has might, fury and so did mine
Never though I traded my elders down
Innocence lost could somewhat justify
Today's techno though rested the case
Fast-paced and red-laced in happy brim
Caring for self and self's new adorn
I wish these times had never seen dawn
Someone's wrinkles and their ignorance
Ahead of Azam in height, brains and vigor
Are these the same kids who held his finger?

MY GRAYING BEARD

Posing a new twist in my story
My shinning, graying, beard
Reminding me of college affairs
My smiling, graying beard
Imitating the youth I once smeared
My teasing, graying beard
Motivating me for chances second
My flirting, graying beard
Annoying my wife with ageing fears
My surprising, graying beard
Preparing me for challenges afresh
My inviting, graying beard
Congratulating me of completed jeers
My flattering, graying beard
Wishing loved ones were near
My dreaming, graying beard
Deepening my wounds of life brief
My concerning, graying beard
Forgetting truth of death so near
My ignoring, graying beard

MALIGNANCY

Eloquently serene, until so blunt
Crafted in pain the news of tumors
Chances unknown, unheard glossary
Grafting fear in organs never in converse
Ignorance and bliss and blessing sought
Suddenly a jolt masked in a mystical cast
Benign is the wish when tests launch
Few get mercy from the monstrous ore
Science a joke when more is revealed
Patient's misery matches family's agony
Few to three, three to six, six to twelve
Doctors talk expiry on statistical math
No reprise, be smoker, spoiler or not
Remorse only, for those moments lost
End will come, when end shall be
Tighten the spirit, hold hand of belief
Behold this war, this effort for hope
Tame malignancy with prayer, resolve

DEEP, DISTANT

Deep, distant the echoes of life's decline
Bitterness of day twilights towards dark
Someone, erodes my passions of then
Memories of yesterday light my emotions
Oceans of tears bloat my sensations
Tears unwanted, yet drool in my eyes
And then, a gentle touch on my shoulder
Unseen, painful and not to be found
Sometimes hearts dwell to meet but don't
Ah..the times when hearts engage forever
Tangles from feelings of life's sorrows
Pains for others though, my own heart
This heart still, remains keeper of my hush
Albeit this strange outcome of my dreams
Dreams but, my own and my precious
Lost the love but never lost its shadows
Deep, distant the echoes of nature sublime
Sweetness of night evokes towards day
Someone, twinkles in my passions of now
Feelings of today conceal in to my memories

THOSE UNKNOWN TEARS

Movement of man by force is atrocious
Identity crisis from ignorance is vicious
Borders have barriers aplenty antireligious
Hearts have no limits to sights ambitious
Grandfather of mine left it outrageous
My feelings towards that land contradictious
Competition with them though ferocious
Individual opinion of people only grievous
Politicians both sides are homogenous
Preaching similar hate la' cancerous
God's own if we see through conscious
Treat others with dignity en' zealous
Ignorance's bliss but negligence ridiculous
Open eyes, invoke mind from envious
Few men sparkled hope with effort righteous
Belittled usually by masses cast in oblivious
Those unknown tears lost in wars hideous
Story same but lessons lost….. Continuous

ROLLING DOWN THE YEARS

Charting age whips my youth
Prime of past peaks the dip
Visions of a better, sweeter old age
Suddenly twist and come around
Broadening waist has settled in
Sleep has started cheating on me
Tears take harder to fall out
Loves stories now raise a doubt
God feels closer and within reach
Calorie counts are but compulsory
Grey hair is white and brighter
Neck has a morning story bitter
Pleated pants are now acceptable
Aren't unfashionable shoes better?
His wife's prettier, my kids smarter
Joining that club of freedom fighters
Eventful, pleasant and a joyride
Rolling down the years, I realized

THROUGH THE FALL

Here I was courage in grasp
Mysteries of nature's wasp
Thinking less and acting more
Always on that fast chore
Water was the buddy of like
Mud the second on the jibe
Insects fell prey to my wiggle
Girls seemed alien and jiggle
Life was great I was ten
Rules not any for brethren
House was prison, bathing struggle
Washing hands was utmost hurdle
Shoes were always dust prone
Why clean something if be gone
Nothing was enough were the bothers
Best were things I saw with others
Three hundred days, a bit more
That year of life was uproar
All that runs comes to a halt
Eventually 1984 ended its roll
Books were heavy, burden as I recall
Lessons however, came through the fall

FATHERS PRETEND

Son asked father holding his hand
Walking the shore, touching the sand
Will you still love me when I fail?
Will you care if my balance derails?
The father just smiles, blinks a smile
Fragrance of love assures the child
Didn't I hold you when you fell?
Costing me handsome in repair
Wasn't I awake when you cried?
Giving up sleep on office's guile
The child's smile raises a doubt
Twists his mind causes a clout
Father thinks when tables turn
Today's man tomorrow old one
With a life of own and matters such
Will this child love me still, as much?
Can love today, guarantee later
Similar would be son to father
Shivering hands, dropping shoulders
Eyes etched, steps in flounders
I will need him to hold me still
He might smile, or his will
Aging is hard I have observed
Depending on others, reserved
Father looks upwards to the high
Grant me love for this love lord my
Loud scream breaks father's spell
Child again, tripped and fell
Father steps down hugs his soul
Assurance again, plays his role
Tomorrow is a mystery, understand
Scared are fathers but they pretend

I WISH

Babies not left in dumpster
Plants grow in pure water
Pearls still remain in oyster
Words all found in Webster
Enough trees for a woodcutter
Dictatorship an option for the voter
Rich too concern for shelter
Invention of a see-through plaster
Noble the job of a cricketer
Saint born a son to a corrupter
Celebration on birth of a daughter
Dark also a complexion neater
Airport security block the blacklister
Police arrest the backbiter
Honesty regains its glitter
Mobiles jam during pray center
Knowledge sought through a computer
Relationships appreciated better
Tears felt beyond being eye water
Bombs explode flowers, laughter
Slave rides camel, walks master
Muslims rewrite history, turn chapter
Tolerance taught matric to inter
People respect wisdom, character
Azam's word understood as writer

WHAT I AM

God's will what I am achieving
Others success what I am appreciating
Self-control what I am exercising
Brutal anger what I am controlling
Hundred percent what I am delivering
Charity heartfelt what I am donating
Advise the one I am self-practicing
Your children like my own, I am adoring
Rights of lesser beings I am protecting
Parent's honor I am polishing
Failure a sentiment I am cherishing
Human rights I am understanding
My own, when wrong I am punishing
Right is right, wrong is…I am agreeing
Beauty, unknown females I am ignoring
My mistakes what I am repenting
My dark past what I am revealing
Troubles between others I am mediating
Oppression what I am challenging
Injustice what I am debating
Inner colors of self what I am painting
Voice of the soul what I am singing
Greatest deeds what I am achieving
But am I really what I am pretending

IN THE SHOES OF A FATHER

Butterflies, stomach, laugh and falter
Strung infancy in the love of a father
Prayers, books, school and a teacher
Pulled childhood in the distance of a father
Intimacies, devotion, loyalty and fresher
Freedom of age in the scrutiny of a father
Grades, job, pay and a brother
Swam adulthood in the vice of a father
Mysteries, love, her and hunger
Teased youth in the fright of a father
Sisters, brothers, kin knit together
Elder hood in the support of a father
Bells, whistles, marriage and sober
Straightened life, advice of a father
Toys, vaccination, feeders and diaper
Molded paternity in the path of a father
Maturity, wisdom, becoming a writer
Realigned existence in the light of a father
Investments, money, bank and weather
Secured some in the opinion of a father
Medicines, illness, doctors and further
Supported guts in the fight of a father
Goodbyes, farewell, death and a mother
Hardened faith in the loss of a father
Tomorrow, hope, belief, all I can gather
Continuation of life in the shoes of a father

THIS OLD HEART OF MINE

This old heart of mine in pain
Waits of those, that time again
Hungry mouths filled with grain
Abandoned children sing in rain
Husbands treat wives the same
Politicians keep promises game
Education is free, must to attain
Money earned is awry of shame
Africa also a part of human chain
Sugar is not traded for aspartame
Immigration is an easy bargain
Ozone is full, there to remain
Cancer unable to reach the brain
Treatment of it is cheap, plain
Lands green, snow on mountain
Homes are built by armies main
Murder becomes unknown name
Villains fall in love without flame
Voice of freedom loud and certain
Laughter that none able to contain
Tears only dwell on joy fountain
This old heart of mine in pain
Waits of those, that time again

JUST NOW

Ambition was wind defying
Whiteness in smile was sparkling
Energy in my legs was oozing
Fire in this heart was pouring
Time, ample for sparing
Enemies many yet kneeling
Love, passion amplifying
Ignorance was motivating
Cream tasted, was not fattening
Computers not many knowing
TV channels few but fascinating
Pockets empty, hobbies flowing
Advice was boring, annoying
Book was a friend, captivating
Cassettes fun, worth treasuring
Memory complex, comprehending
Career aspiration, logic defying
Full of life the breeze blowing
Siblings close, respecting
Faith simple, routine following
Wounds deep but quick in healing
Pain came, pain went unknowing
Friendships easy, self-mending
Just now was here, now eluding
Strange this life, swiftly departing

PEOPLE OF FIRE

Like kings of speed, they race so fast
Only lightening to match, that torrid cast
For some the toe, for some the head
How much you save, once they shed
Power and intuition, with abuse amass
Here they come, with might of the storm
The left arm or the right, the thunderbolt is rocked
Some wear guards and some just fear
Twenty steps or a little more
Full throttle no matter what it bore
Some went higher and some high
Some went straight through the thigh
With no mercy for the willow
No leniency for the soul
Faster and faster off they go
Spitting fire, and at times more
Imran, Wasim, Waqar or Shoaib
The people of fire, the fire no more

Forefathers

Miming at realities bound in facts
Ignoring truth, reasons and hacks
Drilled deep, carved in stones
No matter how much meat on bones
Strange financial problem ambles
God's way, no, nope, shambles
Misery and pain dreadful shatters
Right from wrong family matters
Vital challenge towards prophecies
Chant of family-based moralities
Ibrahim, Musa, Eisa or Muhammad's
Task was of people in ancient jumbles
Life, cuts both ways now and after's
Religion but, of my fore, forefathers

FOUR WIVES, ONE MAN

Motivated by the usual lust as perspective
Men embark on the true Muslim correlative
Usually self-appealing, appeasing prerogative
Though linked to the Quran as a directive
Formation of society the actual narrative
Manipulation though a gross offensive
Why then Jew the only evil operative?
Isn't maneuvering religious script their negative?
Rights of animals are defined in Islam's educative
Man termed superior, why this misrepresentative
Those who argue this method are distinctive
Heinous relationships to them though permissive
Wife, one or many is a subject intellective
First rise to the level of faith appropriative
Protection of society, rights the real objective
Why challenge the all-knowing, all attentive?
When guidelines are provided in clear instructive
Why dwell towards the fire with sins cumulative?
Questioning law is a show of people disruptive
We are getting better in this art destructive
Let's mature to life's true, purposeful subjective
End games of self, rise to Almighty's superlative
Four wives, one man to you an idea obstructive?
Polygamy in Islam an exception, fairness decisive

JIHAD BANO

Defying expectations of her gender
Conquering fears similar to Alexander
Riding challenges of self and tender
Each day new verdicts to blunder
Women struggling for rights wonder
Albeit the supreme instruction vender
God's will, stated in verses encoder
Cover heads, chest amongst alien fonder
Rule after rule in European thunder
Who is being fooled by that pretender?
Nudity, vulgarity outrageously under
Conservation of self however, plunder
Security's issues' biggest spender
Women in veil, hijab, burqa minder
Isn't there some Muslim message louder?
Explain the veil, define purpose grander
Busy are we with matters of silly dodder
Nor are we but those who raise a leader
Epic in scale, larger in subjects broader
Address matters of symbolism, a builder
In absence of such constitution holder
Veiled women will continue to surrender
Virtually the entire globe as forbidder
A war Jihad Bano left alone to consider

FATWA SHOPPING

Convenient, accommodating, extremely possible
This sheikh or the other will surely be flexible
No matter how tainted, shoddy or unfeasible
Money will ensure all boundaries are permissible
Fatwa today is much softer, crunchier and edible
Dollars have made way through channels horrible
What was supposed to be Allah's way, credible
Now disputed, abused and in condition terrible
How much will we sell, knife through, bone visible
Establishment of international bodies audible
Confusion in coalition with confusion invisible
Seeking answers the toughest Islamic tangible
Still flirting differing versions of facts irreversible
You and I are drugging next generations legible
Interest should be interest, east, and west extendible
My fatwa is not your fatwa theory is indigestible
Whatever is subject to interpretation is ineligible
Answers clear, questions welcome, connectible
Fourteen centuries and steady decline, fallible
Changes are needed in all, leaders apprehensible
Multi-marriages, Islamic banking, child brides accessible
Fatwas playing a leading role on grounds collapsible
We must change and change our base combustible
Seek answers with honesty and remain responsible
Azam still heads for masjid though thoughts divisible
Clean heart first, question without prejudice, sensible

THIS DECLINE

The war of bucks is on
People are gasping suborn
Money or not, pockets are slender
Fires breaking in lands of far
Some being lit some unsure
Screaming voices make me feel
Old, abandoned and unreal
Death, sadness, corruption and spice
Hiking fees, kettle or ice
Borrowing and lending evil deeds
Trust and care yesterday's weeds
Welfare nations still with hope
Me and same in horrific grope
Halt this recession almighty
Misery of many is worth mercy
Youth is the loser of this tale
Tomorrow unsure, today stale
Mark the worth of human life
Should be more to this knife

DYNAMICALLY FLAWED

Albeit beckoning, hearty passion followed
The concept difficult now to be swallowed
If your version my version are both allowed
Can symmetry stand when opposites cowed?
Modernity adapted to levels overflowed
Centuries of change has history elbowed
Car, not camel the method we borrowed
Rules of old but we have adamantly clawed
Quran the guide, messenger had vowed
Adaptation the key as he, himself rowed
Not amend laws like people before us brewed
Alignment however a must, should be viewed
Strapping bombs right, wrong, fact endowed
Could law ever be an open subject towed?
Rules of engagement clearly be reviewed
Black or white clarity not somewhat thawed
No concept of mullah a classic tale outlawed
Muslim however an element overshadowed
People's energy towards Islamic state narrowed
Not one has existed since our centuries pillowed
Wishful thinking the train that must be slowed
Start today so next generations aren't widowed
Facts are ignored, stats thwarted and failure chewed
Islam complete, our practice but dynamically flawed

Heavenly lessons poetized

Upon rolling up my sleeves I realized
A dagger unknown peeping galvanized
How could something remain aestheticized?
When I am a true believer humanized
A thought stretched my mind baptized
Could years of polishing have fossilized?
A dark history, inconsistencies fantasized
Truth muddled, breathy facts customized
Immediately after the prophet it actualized
Like a School bunch without teacher capitalized
Two paths from there onwards idealized
Leading to centuries of integrity factionalized
Then the case of death so ardently idolized
Not just self but others' lives terrorized
Our book is the word of God divinized
Interpretation a conundrum we rationalized
Boasting on past glories we criminalized
Generations in misalignment oxidized
At the crossroads of an era digitalized
Our destinies in the hands of few idolized
Leader here and leader there formulized
Leadership busted, tainted and exorcized
Delayed our response others capitalized
Almost right and just wrong contextualized
Africa, Asia or wherever my flag fertilized
Inconsistencies, politics, pain crystalized
Why are we unable to get synchronized?
When every prayer we are so organized
Could it be that simple and factorized?

Clean self, bury demons immortalized
Protect our values, visions rationalized
Recover from our condition uncivilized
We breed poverty, illiteracy territorialized
Blame others of conspiracy dogmatized
Promise honesty, unity, rights un-politicalized
Then Azam preach heavenly lessons poetized

TICKET TO HEAVEN

Iconic, spectacular, brimming with milk, virgins even
You and I dwell to get a ticket to paradise, that heaven
A problem however troubles my Muslim brethren
Killing innocents a sin, happily weighed breakeven
Americans or similar looking usually a reason coven
Revenge, vengeance the account, motive, driven
Kill for this, for that, for difference, beards shaven
Kill in sympathy, empathy, kill for eloping self-chosen
Murder for honor, indifference, my version spoken
Murder in anticipation, sometimes for promises broken
Slaughter for incorrect treatment, others leaders doyen
Slaughter to uphold respect, slaughter for failing to listen
Butcher for race, for orientation for plain truth bitten
Butcher to show mine is bigger, butchery so often?
Deemed sufficient to get on the train, ride forgiven
In truth, judgmental, savagely, downright craven
Hatred the game, religion the name, end barren
All will end up in heaven so why the need to burden?
Awaken Azam from your history's worse era darken
Back to our dark ages, back to bury daughters open
How and when and why did we get this theory rotten
Spirituality key, righteousness the path to skies seven
Intolerance the problem, religion our excuse beaten
Book of law, practiced, proved by the prophet chosen
The book unchanged, the message lost to ears deafen
Ticket to heaven though, has peace first, on it written

A RELIGION CALLED CHILDREN

As we continue to feed the beast of greed
As we plant the next generation of our seed
With tolerance levels worse than stray dogs
With pills easier to get, cure though in clogs
Ask whomever, white, black, brown or me
Ask through cross, crescent, stone, fire, thee
Me, mine, my kind the only song we sing
Me, mine, my motive, my dance my thing
Why beat around the bush is my question
Why not break this code, reveal perception
I hate you, you hate me and we hate them
How long but, we will practice this anthem
Caught in our fire of this loud hate deafen
The story of Godly hope, the tale of children
Can I beg the attention of that preacher?
Can I muster a solution for every creature?
A solution which should contradict with none
A new chapter, a new angle, a better clone
To err is human, can I request you to listen
Can there not be a religion called children
No matter how, no matter the question
Every child treated with love, affection
Most points for who embraces an orphan
Cookies the trump and without any gun
Olympics for young ones not steroid-ridden
Food free for each, every tummy hidden
Let capital crime then be to hire hands small
Capital punishment on molestation the call

Freedom my offer even before education
Protection until teenage in every nation
The roots are drenched in chemicals many
And we are wondering of our constant agony
Children today are paying the price
Some for liberty and some for rice
Azam rests his case, encourages your action
My child or yours, in children lay our religion

Rituals of Ihram

Billions digested through a simplistic scam
In the name of thy lord, by a pious sham
Businesses flourishing, money minting jam
As you, I and the elderly usher our salaam
Not difficult to draw this hidden diagram
When enemy within, concern being dirham
Ultimate goal, seventy virgins, fruit ashram
Worldly gains the aim too by chanting kalam
What further depths will we Muslims slam
Dramatic slide, consistent our cheatogram
Preaching elders hijab and respecting madam
Quickly do enlightened ones forget who I am?
Marrying 10 year-olds for a greater wham
Not the teachings of the blessed imam (pbuh)
1400 years for finding the complete nizam
Until when will we not align with true gram?
Alignment and purpose the only way program
If not then we will continue to fail this exam
Praying, following are being labeled as Islam
Azam discerns the soul from rituals of ihram

NOT AN ENEMY OR A DISBELIEVER

Unwilling to use the common wisdom ever
Braves the stream of nothingness achiever
Adamant on rituals and only divine deliver
Mostly content with prayers, the believer
Systematic demise of yesterday's fever
Still constructing the system the improver
Failures aplenty that generations carryover
Stuck to his guns the mercy perceiver
Cherishing past glory is also a hangover
Rise to the present, wake up you pushover
Not though your preference to crossover
Game has been changed by the deceiver
Alignment a must or consequences graver
You must assemble, nature will raise a driver
Time ripe and calls for true love to uncover
The humble servant, passionate, noble lover
Spark human rights sense, humanity makeover
Become the leader, yes you, the misbehaver
Admonish laziness then push the prayer lever
Fathers must change and become the caregiver
Not possible to limit religion to a single cover
Piousness not more in beards or less in shaver
Seventh graders carry the hope to maneuver
A tomorrow with passion of the youth engraver
Let those scars mean that the eternal hurt is over
Peace, law, harmony should please your forgiver
Not a bad phase to begin the journey to discover
A lost brother is not an enemy or a disbeliever

ACTION, THE ELOQUENT COUNTER

Not that the mystery didn't unfold the fact bitter
Numb however were the ears to this laughter
Fear has defined me, you and the sacred voter
Fright of someone's wealth or human slaughter
Defining this moment, adopt to the enemy faster
Not a head on collision will resolve this charter
Collectively we must devise a strategy perimeter
If every individual unites towards the hunter
Can it survive, this seemingly huge monster?
Enemy of state, home grown or external foster
Shouldn't matter even if lifts own clan's shelter
Not resolved, this thorn will be hard to administer
Are you ready, yes you that strong youth cluster?
United we stand, divided we are all but clutter
Clarity of purpose, not music festivals banter
Some within us, half here and half defaulter
We handed them reasons aplenty to falter
Let's align with Islam, from both sides barter
Conundrum is to draft upper and lower filter
Until when TV be ok for news and not after
What parents stop here, kids do on computer
Why not define a threshold, clear parameter
Define allowable limits, publish the matter
If not this, next generation will surely register
Lengths of beards, types of hijab, every chapter
God's sake, ages when to marry thy daughter
Classes in pilgrimage albeit similar our water
Could this be possibly accepted in the hereafter?
Heaven but Azam, will not be served on a platter
Inaction is decay, action, the eloquent counter

She has fire

Yes I see it, oh yes it is there
She is there and I am around
There is a feeling
There is peace
There is commotion
Secret emotions are lightening
Storms of will are rising
Fear of a mistake is in my heart
Arrogance is inevitable in her stance
The way she moves is causing a stir
If this is love then I am not dreaming
Is she alone is a question
Does it matter is a challenge
Can I own her for life?
Is this feeling enough for a strive
She goes a distant and I am chilled
Is this a dress or is this a flame
What I have is a famished desire
What she has is "Fire"

THE QUEEN OF MELODY

Sparking the charms of harmony
The undisputed queen of melody
For the souls who sought tranquility
The arrogance and harp of beauty
Voice such that an era subsequently
I was enchanted by her vocals merry
Sound recordists vouched for her mystery
Danced when, the gauges of technology
Spell-binding were sounds rhythmically
Urdu, Punjabi, every word addictively
Azam's words are unjust actually
Queen's honor, ardent fan's poetry
Instruments struggled to keep jointly
Composers often relied on beat jugglery
Her charisma was downright honorary
National defense inspired by her artistry
Her arrival set an ambience obediently
Legends paid rich tributes fittingly
When she performed with her mastery
Hundreds imitated her style desperately
None reached close to her skill exemplary
Yesterday's queen now lost in history
A decade gone since her last act heavenly

GEOGRAPHICAL SIN

There was a balance upheld all along
Until uncalled saviors hit their song
Not all was right but some law did prevail
Am I to judge rules of your faith and veil?
Bending forward to bow was a truth black
Bending backwards has broken their back
Dictators usually result in places of mess
But are chosen by others savvy of chess
Two wrongs are not making it bright
A better right is the only one right
Teaching me democracy lessons when
Culturally my kind knows not this acumen
Choosing between several useless
A choice tough when food is so less
Underlying condition not at all a priority
That's how we have treated this actuality
Fresh perspectives the need of all
Else next half century will further fall
Future technology focuses of robots
Why not then kids suffer as maggots?
Living creatures your love, dogs and all
Arab, African babies not worth overall?
Available to everyone, that is peace
Money with few, rest dwells in menace
Politically incorrect, this war this fight
When all that little one wants is a bite
Babies are dying in this colossal carnage
Misery, hunger rampant in our digital age
Can't we come together you, I and them?
Lift humanity from doldrums of mayhem
Some thought, some feeling from within
One voice against this geographical sin

I SEE YOU

When winds bring cloud
When rain runs the rout
When food tastes great
When friends jot a date
When cricket balls fly
When prayers call high
When she cooks fish
When fruits slur to dish
When hair begins to curl
When news ups the mill
When radio churns noise
When history skips reprise
When honesty is meant
When cakes are sent
When magazines are read
When plants are fed
When others are helped
When nothing is shelved
When chicken is bought
When someone coughs
When prizes are won
When naps are fun
When headache strikes
When laughter bites
When patience is game
When picking a baby name
When nothing is the same
When hope is to meet again

Printed in the United States
By Bookmasters